TEA WISDOM

INSPIRATIONAL QUOTES AND QUIPS ABOUT
THE WORLD'S MOST CELEBRATED BEVERAGE

AARON FISHER

TUTTLE PUBLISHING
Tokyo • Rutland, Vermont • Singapore

Published by Tuttle Publishing, an imprint of Periplus Editions
(HK) Ltd., with editorial offices at 364 Innovation Drive, North
Clarendon, Vermont 05759 U.S.A.

Library of Congress Cataloging-in-Publication Data

Fisher, Aaron.
 Tea wisdom : inspirational quotes and quips about the world's most
celebrated beverage / Aaron Fisher. -- 1st ed.
 p. cm.
 ISBN 978-0-8048-3978-5 (pbk.)
1. Tea--Quotations, maxims, etc. 2. Tea--Philosophy. I. Title.
 GT2905.F57 2008
 394.1'5--dc22

 2008053311

ISBN: 978-0-8048-3978-5

North America, Latin America & Europe
Tuttle Publishing
364 Innovation Drive
North Clarendon, VT 05759-9436 U.S.A.
Tel: 1 (802) 773-8930; Fax: 1 (802) 773-6993
info@tuttlepublishing.com
www.tuttlepublishing.com

Asia Pacific
Berkeley Books Pte. Ltd.
61 Tai Seng Avenue #02-12
Singapore 534167
Tel: (65) 6280-1330; Fax: (65) 6280-6290
inquiries@periplus.com.sg
www.periplus.com

First edition
12 11 10 09 10 9 8 7 6 5 4 3 2 1

Printed in Singapore

TUTTLE PUBLISHING® is a registered trademark of
Tuttle Publishing, a division of Periplus Editions (HK) Ltd.

Page 1: "Tea without Tea." *Illustration by the author.*
Page 2: Tang Dynasty Tea Brazier by Master Chen Qi Nan.
Pages 6-7: Oxidation of Puerh tea leaves in Yunnan.
Opposite: Preparing Tea. *Illustration traditionally attributed to
Lin Sung-nien, Sung Dynasty. From the collection of the National Palace Museum, Taipei.*

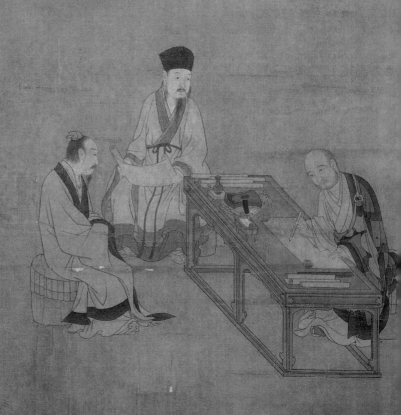

For my teacher, Master Ling Ping Xiang,
and the serene joy he inspires; and for all
the quiet cups of wisdom from East to West,
around the world. —*the author*

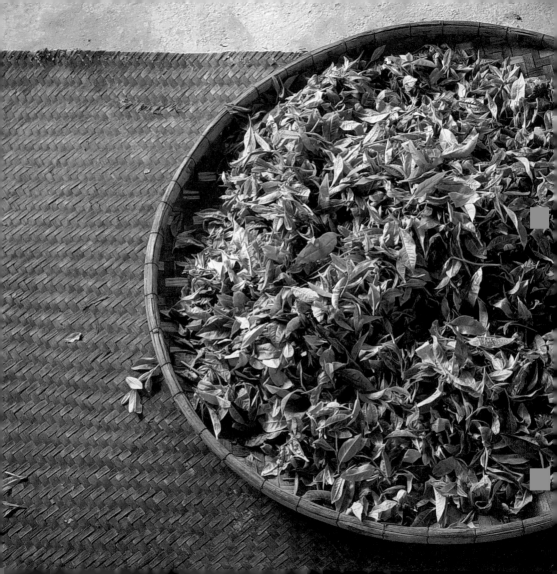

Contents

Introduction 9

Chapter One: Good Living 16

Chapter Two: Good Health 48

Chapter Three: Good Spirits 84

Chapter Four: Good Company 112

Chapter Five: Traditions 144

Chapter Six: Reviving Yourself 180

Chapter Seven: Reflection and Meditation 208

INTRODUCTION

They say it was the Divine Farmer, Shen Nong, who first sipped the Leaf, sitting in idle meditation beneath its great boughs when a single leaf fluttered calmly into his hot water. Others believe a tea sprout sprang up from the discarded eyelids of Bodhidharma, torn off by the stern sage for betraying him with a drowsy flutter during his nine-year vigil. In following the great tea scroll down from these times of legend, before even the calligraphy of history was first stroked, we might find the wizened jungle shamans who carried its leaves in their medicine pouches; further unraveling Daoist mendicants passing a steaming bowl of truth between them, the wind passing through the soughing brazier all the sermon they would ever need; past other bearded sages, monks and nuns sipping green tea in unison as the summoning gong drifts out the temple doors to the point where its vibrations meet silence; and then only would this hoary silk roll, saffroned with age, reach the point where the great tea sage Lu Yu first brushed the *Classics of Tea*, starting the library of tea words that fill this book, inspiring us with a "Tea Wisdom" as true now as it ever was.

All the wisdom of this book, spanning centuries and continents is but a single steeped and poured truth: that at its center the calmness inherent in this ancient herb, steaming gently in water, unfurls not in a pot, but in our Heart.

Beyond that calm place where we all drink tea—out of friendship, meditation, or to our health—we might say that tea is inspiration, spirit, ceremony, and breadth, calm comfort and amicable joy: Its liquor having fueled a long list of poets, painters, and calligraphers who created under its influence; mendicants, monks, and nuns who tended its leaves, drinking for meditation and as an expression of an ineffable wisdom passed from master to student; not to mention the museums of ceramics, woodwork, metalsmithing, and other arts explicitly devoted to the utensils used in tea preparation. Tea has christened weddings and funerals, been offered to gods and demons both, sat steaming between friends, enemy generals and their nighttime stratagems, and the first meeting of lovers—entwining itself around the human story in a romantic and spiritual sentiment as fragrant as its own aroma.

From East to West, in mythic lands, ancient mountains, or modern tea houses that harbor peace amidst bustling cities, we drink tea because it makes us civilized; we drink it because of its inherent quietude, that we share in a moment of peace away from

all the trials and tribulations of life; we drink tea because it affirms an ancient dialogue between Man and Nature through the earth, sky, wind, and rain that bore it. Tea brings together friends and lubricates social discourse with a calm joy that lets us be ourselves in the spirit of sharing. Why else would so many cultures so separated by age and distant in space make tea a time for relaxation, contemplation, meditation, or at least a good chat? Could more be said of Wisdom?

No matter what one believes about the greater movements of our world and lives within it, a human life passes by in so many ordinary moments—all filled up with our daily works. And if we don't find our wisdom in any of these, whether in part or complete epiphany, we'll have passed the greatest part of our lives by, never having celebrated the small pleasures like a quiet cup of tea on a cool evening, as the sun sets behind the distant mountains. There is a way of experiencing what we've learned of ourselves, the universe and truth through the most ordinary quotidian moments, and Nature has offered us more than one catalyst to that quiet at its center.

Ancient healers and wise men knew the importance of living in tune with Nature, and most all our current social, political, psychological, and environmental problems relate at least in part

to the fact that we've made this conversation one-sided, turning a deaf ear to Nature. How few of us know the stars, the trees, or even the weather as intimately as even the lowliest farmer once did? These sages knew that to be truly healthy—mind, body, and spirit—a human must alternate between periods of stillness and activity just as Nature herself does. In the hustle and bustle of modern life, we often forget to take the time to be still, to the point where it is often uncomfortable and alien to us. Through tea, we might achieve a deep serenity and equanimity in ourselves. The nature of the cup is without a mind, without worries and cares, and its fragrance entices us into that space effortlessly. If we but take the time and relax into our senses, we'll find the mountain air and sunshine, the wind and rain and the calm stillness of Nature in every sip. A cup of tea has always been about this, wherever and whenever it has been drunk, regardless of whether it is called "peace" or "wisdom." Even the modern news about tea's health benefits is but another way of showing that those who drink it wish to be free of the concerns that come with a physical body in a worldly life.

Tea has always meant different things to different people, though looking at the long scroll of tea history, one must recognize that its ultimate expression is as a meditation—a step towards

the deep and silent space just beyond the threshold of our hearts, when they're opened. A life without meditation is as barren as the dingy streets of a world that has lost touch with itself, in need of some balming herb that can be brewed to quietude and equanimity. After that, less significant but also important, I think tea can be about enjoying special places, gathering wood and water from a mountain, sipping a cup while the sun rises or sets, or perhaps in a moonlit bamboo grove as the ancients were wont to find, their tea sets bundled up in baskets. If not these, then at least tea is famous for gracing a conversation like nothing else, letting us put down our pretensions—hang our outer *kimonos* on the Cherry tree—and show our true faces to friends and family. It inspires us to be civilized, to talk through our problems, share and give, ideally resulting in well-mannered, respectful, and humble people.

In this book you'll find wisdom of all these kinds and more. I've tried to capture the poetry of tea, from the forest to the farm, to the European drawing room; the simplicity and celebration of the fact that even the smallest aspect of life can be divine; the dialogue between Man and Nature occurring through the cup, as well as the tradition of passing on transcendental experiences through tea. The ancient Daoists said that tea was "Daoism in disguise," the Japanese have the well-known adage that "the taste

of tea is the taste of Zen," and one need not look to the East alone for tea wisdom, as even the first missionaries to China and Japan recognized its worth and, especially in Japan, began tea rooms in their own convents—let alone the great poets and scholars like Emerson, Pope, James, Adams, and more who found inspiration sipping tea.

Tea speaks to the individual, as it should, because it is wise; and its language isn't Eastern or Western, but natural and primordial. When we hold a cup of tea with mindfulness and focus on it, the moment becomes real and true, which means we become real and true. May you find in this book the cup that these bits of wisdom were inspired by, for only in drinking of it will you have an understanding and affinity with the great men whose names fill this book. For each quote, I would wish there is a quiet cup of tea, seeking out the wisdom that the author suggests. You can't read of tea, not really; though you can be inspired to put the kettle on and reach for your old friend the pot one more time. In that way you'll travel through the centuries, from East to West, and experience for yourself why a simple leaf and water can combine, Alchemically—magically—and realize that the highest truths can be had in this cup of tea.

CHAPTER ONE

GOOD
LIVING

There is a subtle charm in the taste of tea which makes it irresistible and capable of idealization.

—*Kakuzo Okakura*

Whenever friends and family sit around a table, a cup of fragrant tea will lend its rich aroma and warm presence to any occasion.　　　—*Ling Wang*

A true warrior, like tea, shows his strength in hot water.　　　—*Chinese Proverb*

Pages 16-17: "Bliss is a tong, cup, pot and water, falling." *Illustration by the author.*

What we call cha-no-yu is nothing more than the occasion for the partaking of a bowl of tea. It is only the ordinary act of eating and drinking that can be seen in daily life. Nevertheless, in the requirement that we sweep away the impurities of this world, we can see the operation of an other-worldly concept that makes us conscious of having put aside the concerns of mundane life.

—*Sen Soshitsu XV*

Wherever you are drinking your tea, whether at work, in a café, or at home, it is wonderful to allow enough time to appreciate it.

—*Thich Nhat Hanh*

Surely everyone is aware of the divine pleasures which attend a wintry fireside; candles at four o'clock, warm hearthrugs, tea, a fair tea-maker, shutters closed, curtains flowing in ample draperies to the floor, whilst the wind and rain are raging audibly without. —*Thomas De Quincy*

In the domain of Buddha ancestors, drinking tea and eating rice is everyday activity. This having tea and rice has been transmitted over many years and is present right now. Thus the Buddha ancestors' vital activity of having tea and rice comes to us. —*Dogen-Zenji*

Opposite: The Eighteen Scholars enjoying a cup of tea. *Illustration by Anonymous, Traditionally attributed to the Sung Dynasty. From the collection of the National Palace Museum, Taipei.*

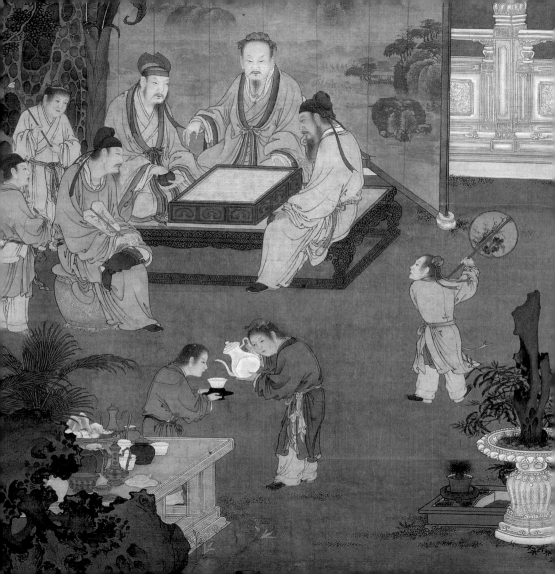

When we rise in the morning, we ready our daily firewood, rice, cooking oil, soy, salt, vinegar, and tea.

— Chinese adage

Mountain flowers are bringing out their beauty while tea sprouts their fragrance. *—Chen Chong Ping*

Tea is a divine herb. There are ample profits to be had in its cultivation. It purifies the spirit of the one drinking it; and it is esteemed by the nobles and public alike. Truly tea is a necessity in the daily life of man, and an asset to the commonwealth.

—Xu Guang Qi, Book of Agricultural Administration

Tea is quiet and our thirst for tea is never far from our craving for beauty. —*James Norwood Pratt*

For if I could please myself I would always live as I lived there. I would choose always to breakfast at exactly eight and to be at my desk by nine, there to read or write till one. If a cup of good tea or coffee could be brought to me about eleven, so much the better. —*C. S. Lewis*

A place to escape to when one cannot ease one's cares in the mountains.
The hut beneath the pine within the city

—*Toyohara Sumiaki, quoted by Murai Yasuhiko*

Teaism is a cult founded on the adoration of the beautiful among the sordid facts of everyday existence. It inculcates purity and harmony, the mystery of mutual charity, the romanticism of the social order; it is essentially a worship of the Imperfect, as it is a tender attempt to accomplish something possible in this impossible thing we know as life.

—*Kakuzo Okakura*

Opposite: Sanctuary in green.

The pine-filled winter wind
Blows through my bamboo stove,
And my over-handled Zisha teapot
Whistles in response.　　　　　　—*Su Dongpo*

Tea-making is a ritual that, like the drink itself,
warms the heart somehow.　　　　—*James Norwood Pratt*

Now it is wheat harvest time and at any inn you visit, newly picked tea is served. *—Kyoroku*

Tea does not lend itself to extravagance. *—Lu Yu*

If the bitter leaves of tea are taken over an extended period of time, one's power of thought will improve and quicken. —*The Dissertation on Foods*

Each cup of tea represents an imaginary voyage.

—*Catherine Douzel*

The rush-thatched roof looks cool; even from the bridge one can make out the aroma of tea.

—*Hazan*

Opposite: Kettle for Tang Dynasty style tea, by Master Deng Ding Sou.

An elder tea master was invited to a session held in the capital. The noble who sponsored the event meant to test him. As the master was walking down the path to the tearoom, a gun was fired. In awe, all the guests noticed that the master's pace had not wavered in the slightest when the shot startled those that had known about it all along. His practice in the Way of Tea had established his awareness beyond the world of dust.

—*A. D. Fisher*

Though I cannot flee
From the world of corruption,
I can prepare tea
With water from a mountain stream
And put my heart to rest. —*Ueda Akinara*

Tea is drunk to forget the din of the world.

—*T'ien Yiheng*

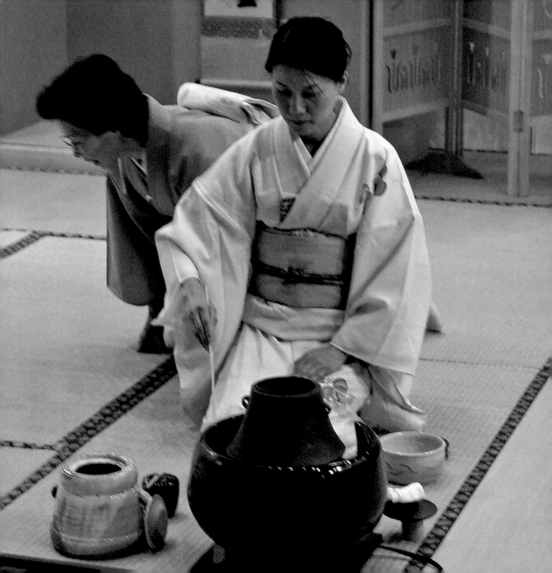

Emperor Qian Long of the Qing Dynasty was a great tea man. In the later years of his reign, he would often retire to some secluded spot for a day of tea drinking. They say that on one such occasion, his top councilor asked, "How can the nation go without the wisdom of its emperor for a day?" Grinning, the emperor replied "And how can that emperor go without his tea for a day?"

—*A. D. Fisher*

Opposite: Cha-no-yu, the Japanese tea ceremony.

There are few hours in life more agreeable than the hour dedicated to the ceremony known as afternoon tea.

—*Henry James*

There is no trouble so great or grave that cannot be much diminished by a nice cup of tea.

—*Bernard-Paul Heroux*

As a domestic art form, tea, like other such pas-
times, is vulnerable to vulgarization, neglect, and
commercialization. In the modern world, where
mechanization and mass production have taken
over so much, honest craftsmanship is fighting a
losing war. —*John Whitney Hall*

Tea to the English is really a picnic indoors.

—*Alice Walker*

Oftentimes, people will just feel a general sense of ease or comfort when drinking good teas.

—Zhou Yu

In an age when everyone is constantly busy and short of time, what could be more enjoyable than taking time to indulge in what was once part of everyday life, but has now become a luxury— afternoon tea.

—Lesley Mackley

Opposite: "'Gone!" says the tea monk.

My hour for tea is half-past five, and my buttered toast waits for nobody.　　　　*—Wilkie Collins*

Tea is one of the main stays of civilization in this country.　　　　*—George Orwell*

The tearoom is made for the tea master not the tea master for the tearoom.　　　　*—Kakuzo Okakura*

The simplicity of the equipment and decoration of the tea ceremony allows minds to think about the natural beauty of things they may not have noticed otherwise. Remember, it is not a grand display of artwork that impresses people here, but the simplicity and beauty of the smallest items. Bringing attention to these things is the most important aspect of the tea ceremony.

—*Shozo Sato*

If you have one teapot
And can brew your tea in it
That will do quite well.
How much does he lack himself
Who must have a lot of things?

—*Sen Rikyu*

Keeping from getting upset, keeping on
making tea, it is the end of the year.

—*Ganzan, translated by Shaun McCabe and Iwasaki Satoko*

Indeed Cha-no-yu may be considered an epito-me of Japanese civilization, for it is a well-blend-ed mixture of elements drawn from the two most ancient cultures of the East eclectically acquired by extremely able and critical minds capable of discerning exactly how they could best use it for the convenience and education of their people.

—*A. L. Sadler*

[A famous] poem on tea speaks of the froth as burning with brilliance, and says that it must be as lustrous as freshly fallen snow and as luscious as the spring lotus.

—*Lu Yu*

The fallen needles blanket the path to the tearoom.

—*Shiki, translated by Shaun McCabe and Iwasaki Satoko*

Don't watch with your eyes or turn your head to listen, just fill your heart with Cha-no-yu.

—*Sen Rikyu*

With regards to the water placed outside in the stone basin, it has always been necessary most of all to clean and purify the heart.

—*Rikyu, as attributed in the Namporoku*

I take pleasure in tea, appreciating it with my spirit and therefore cannot explain why. The spirit of the Way of Tea, when put into words, seems too banal.

—*Sen Joo*

Opposite: Guyi Teapot by Master Deng Ding Sou.

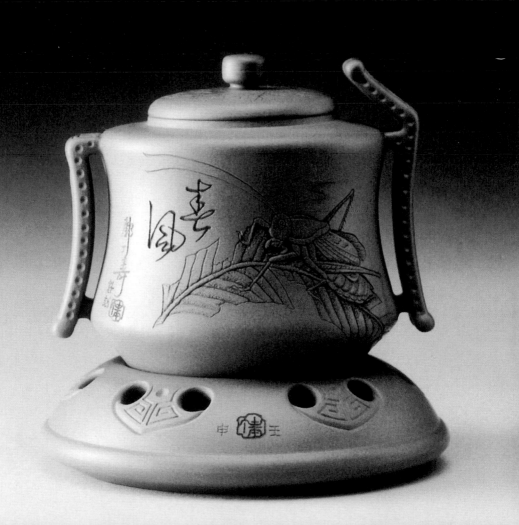

I hope next time when we meet, we won't be fighting each other. Instead we will be drinking tea together.
 —*Jackie Chan, Rumble in the Bronx*

The tea master loves
Dandelion flowers on the roadside
At home a young maiden
Reads an ancient romance
In a lovely prose

—*Basho, translated by Makoto Ueda*

A practitioner of tea in the countryside sent some gold to Rikyu with a request that he purchase for him a tea utensil of any kind. Rikyu spent the entire amount of money on white cloth, sending it with the comment, "With tea, even when one has no nice utensils, if only one has clean cloth for wiping the bowl, it is possible to drink tea."

—Sen Sotan

CHAPTER TWO

GOOD
HEALTH

Most medicines are used to treat but a single sickness, but tea is a panacea for all illness.

—Eisai

The highest quality teas have creases like the leather boots of Tartar horsemen, curl like the dewlap of a hefty bullock, unfold like mist rising out of a ravine, gleam like a lake touched by a breeze, and are wet and soft like a forest floor newly swept by rain.

—Lu Yu

Pages 48-49: "One man's treasure." *Illustration by the author.*

Tea has the blessing of all deities

Tea promotes filial piety

Tea drives away all evil spirits

Tea banishes drowsiness

Tea keeps the five internal organs in harmony

Tea wards off disease

Tea strengthens friendship

Tea disciplines body and mind

Tea destroys the passions

Tea grants a peaceful death.

—Attributed to the monk Myoe, as quoted by Plutschow

The first cup moistens the throat;
The second shatters all feelings of solitude;
The third cup cleans the digestion, and brings to
forethought the wisdom of 5,000 volumes;
The fourth induces perspiration, evaporating all
of life's trials and tribulations;
With the fifth cup, the body sharpens, crisp;
And the sixth cup is the first step on the road to
enlightenment;
The seventh cup sits steaming—it needn't be
drunk, as from head to feet one rises to the
abode of the immortals.

—Lu Tong

Opposite: Tea from when our grandfathers were young.

Tea has been one of the saviors of mankind. I verily
believe that, but for the introduction of tea and
coffee, Europe might have drunk itself to death.

—*Sir James Crichton-Browne*

Tea does our fancy aid,
Repress those vapors which the head invade
And keeps that palace of the soul serene.

—*Edmund Waller*

Tea has countless forms. Tea may be shriveled like a barbarian's boots. There are cakes that look like the dewlap of a wild ox, folded and hanging; still others look like the curling eaves of a house. It can look like mushroom clouds, round as wheels, scudding from behind mountain peaks. There are tea leaves that can surge and leap, like a zephyr across water. Others will look like smooth clay the potter's son purifies in water. And still other teas are like freshly planted fields in a sudden rain, twisting and turning in rivulets. These are the very finest teas.

—*Lu Yu*

No matter what color your skin, or what language you speak, when you sip a cup of clear tea giving off a delicate fragrance, and when you feel deeply that it helps not only produce saliva and slack the thirst, dispel sleepiness and weariness, but also prevent disease and benefit health, you cannot help but praise highly its wonderful effects, and hold in esteem the people who produce it.

—*Yang Jiang Ming*

Tan Chiu was an Immortal

Who cared nothing for delicious food.

Having picked some tea, he drank it,

Then he sprouted wings,

And flew to a fairy mansion,

To escape the emptiness of the world.

Now he lives among the clouds.

In a palace unknown to men.

His tea is made in a golden kettle

By a young immortal dwelling

On a peak amidst the clouds.

How worthless Lu Yu's Classic

In comparison with that!

—*Chiao Jen*

According to Daoist beliefs, tea could contribute
to good health and long life.

—Ling Wang

The aroma of Chinese tea prevails for thousands
of years;
Leaves and springs cover half the land;
Fertile soil, sweet fountains and skilled masters
Pluck your health and enhance your energy.

—Fei Xin Wo

We may easily imagine that a person so involved in Cha-no-yu would welcome two or three days away from it, but this is not the thought of one wholly committed. For true practitioners, apart from Cha-no-yu there is no life; each new day is itself the way of tea.

—*Hamamoto Soshun*

Tea, which refreshes and quietens, is the natural beverage of a taciturn people.

—*C.R. Fay, English Economic History*

If you ask Zen people they will say tea is not something that you pour with unawareness and drink like any other drink. It is not a drink, it is a meditation; it is a prayer. So they listen to the kettle creating a melody, and in that listening they become more silent, more alert.

—*Osho*

One does not prepare the water for one's own use, but rather participates in and enriches the water's existence as the water participates in and enriches one's own life. In this relationship, one experiences both a sense of wonder in the existence of the water just as it is, and a profound sadness that reverberates through the shared existence.

—*Dennis Hirota*

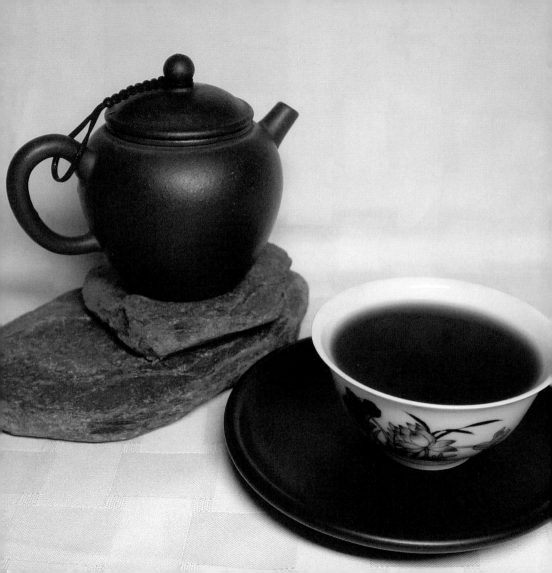

[I am] a hardened and shameless tea drinker, who has for twenty years diluted his meals only with the infusion of this fascinating plant; whose kettle has scarcely time to cool; who with tea amuses the evening, with tea solaces the midnight, and with tea welcomes the morning.

—Samuel Johnson

Opposite: "The elixir of life (*bu lao dan*)."

Tea is beneficial to health, as the "Qi" clears all blockages and cures ailments.

Tea helps refresh one after a night of drinking alcohol.

Tea, mixed with other things like nuts or even milk can provide nourishment.

Tea can cool one off in the heat of summer.

Tea helps one slough off all fatigue and drowsiness, promoting an awakened mindset.

Tea purifies the spirit, removes anxiety and nervousness and brings ease and comfort, conducive to meditation.

Tea aids in the digestion of food.

Tea removes all toxins from the body, flushing out the blood and urinary system. Tea is conducive to longevity, promoting longer, healthier life.

Tea invigorates the body and inspires the mind to creativity.

—*Traditional Tang Dynasty list of reasons to drink tea*

Tea had come as a deliverer to a land that called for deliverance; a land of beef and ale, of heavy eating and abundant drunkenness; of gray skies and harsh winds; of strong-nerved, stout-purposed, slow-thinking men and women. Above all, a land of sheltered homes and warm firesides—firesides that were waiting—waiting, for the bubbling kettle and the fragrant breath of tea.

—*Agnes Reppiler*

The water is boiled, and the tea is great.

—*Chinese Proverb*

[The old man] named his small room Konnichian
(meaning that only today—the present—matters)
and lived with the thought of spending one more
day with his aged body facing a tea kettle.

—*Sugiki Fusai, as quoted by Kumakura Isao*

My experience...convinced me that tea was better
than brandy, and during the last six months in
Africa I took no brandy, even when sick taking
tea instead. —*Theodore Roosevelt*

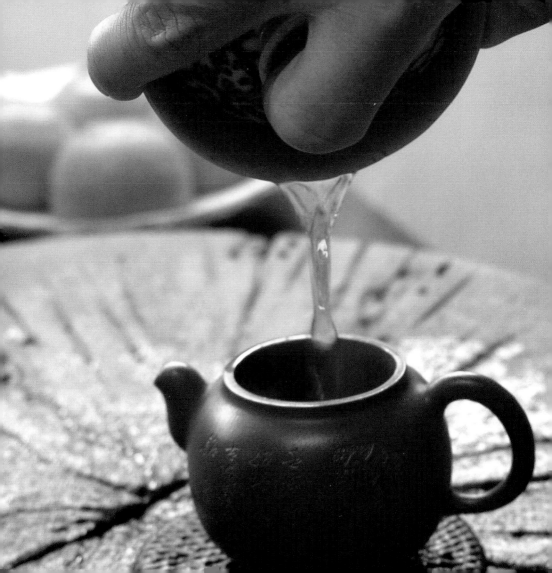

There is a traditional Chinese adage that good tea won't be good if brewed with poor quality water, though average tea can be excellent if the water is good. No single element plays as decisive a role in our tea as water. The tea session begins with the boiling of water and ends with drinking a cup of liquor that is also predominantly water. Where we source our water, therefore, is essential to the overall harmony and dialogue with nature that tea has always inspired in "men of tea." The best water, since ancient times, came from

mountain springs, collected at dawn when the Yang of the sun was influencing the Yin of the water. In finding, carrying, and storing the best waters, the ancients found a way to connect tea to a much deeper aspect of living, as our bodies are mostly water and drinking it our most essential activity. Don't lose the chance to find nature again by taking the water used in tea seriously— the mountain hike will do you good beyond the grace, spirit, and flavor it will lend your tea.

—*A. D. Fisher*

Cha-no-yu as we now practice it is not the Cha-no-yu that has been discussed and proclaimed in the past by the accomplished teamen of China and Japan. Neither is it to partake of tea having grasped its essence through scholarly study. It is simply to drink tea, knowing that if you just heat the water, your thirst is certain to be quenched. Nothing else is involved.

—*Rikyu, as attributed in the One-Page Testament of Rikyu*

It is very strange, this domination of our intellect by our digestive organs. We cannot work, we cannot think, unless our stomach wills so. It dictates to us our emotions, our passions. After eggs and bacon it says, "Work!" After beefsteak and porter, it says, "Sleep!" After a cup of tea (two spoonfuls for each cup, and don't let it stand for more than three minutes), it says to the brain, "Now rise, and show your strength. Be eloquent, and deep, and tender; see, with a clear eye, into Nature, and into life: spread your white wings of quivering thought, and soar, a god-like spirit, over the whirling world beneath you, up through long lanes of flaming stars to the gates of eternity!"

—Jerome K. Jerome

In China, tea is regarded as one of the main aids to a long and healthy life...in remote mountain areas people often live for over 100 years. There they drink the best tea, which grows at high altitudes and is gathered and made by local people, using pure mountain water. —*Lam Kam Chuen*

I'm in no way interested in Immortality, I only yearn for the taste of tea. —*Lu Tong*

The mere chink of cups and saucers tunes the
mind to happy repose. —*George Gissing*

Cha-no-yu therefore is like a symphony. Its
multiple voices blend in harmonies that may
embrace strong dissonances, to be resolved, or left
unresolved, in the course of the performance.

—*William H. McNeill*

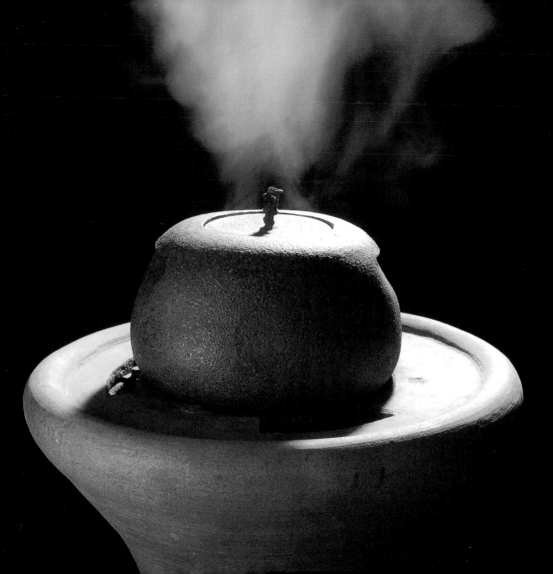

Do not gulp the tea but sip it slowly allowing its fragrance to fill your mouth. There is no need to have any special attitude while drinking except one of thankfulness.

—Pojong Sunim, a Korean tea master, quoted by Stephen Batchelor

Better to be deprived of food for three days, than tea for one. *—Chinese Proverb*

All well-regulated families set apart an hour every morning for tea and bread and butter.

—Joseph Addison

Tea is an elixir for good health, a miraculous means of prolonging one's life

—Sen, quoted by Ryofu Pusse

[Tea] has a strange influence over mood, a strange power of changing the look of things, and changing it for the better, so that we can believe and hope and do under the influence of tea what we should otherwise give up in discouragement and despair.

—The Lancet, London, 1863

79

天然無汙染高山茶

The tea session is modeled after the silence of retreat; a time to enjoy a life far removed from daily existence.

—Sen Joo

Tea is a part of daily life. It is as simple as eating when hungry and drinking when thirsty.

—Hamamoto Soshun

Drinking a daily cup of tea will surely starve the apothecary.

—Chinese Proverb

Hearing the sound of tea, we pass through the mosquito-repellent incense and step inside.

—Soto

She may want a martini, but make her drink tea.

—*Alice Taylor*

To honor my tea, I shut my wooden gate,
Lest worldly people intrude,
And donning my silken cap,
I brew and taste my tea alone.

—*Lu Tong*

Baddhim Saranim
gachami

Dhammam Saranam
gachami

Sangham Saranam
gachami

CHAPTER THREE

GOOD
SPIRITS

I smile, of course,

And go on drinking tea,

"Yet with these April sunsets, that somehow recall

My buried life, and Paris in the Spring,

I feel immeasurably at peace, and find the world

To be wonderful and youthful, after all."

—*T. S. Elliot*

If a man hasn't any tea in him, he is incapable of understanding truth and beauty.

—*Japanese Proverb*

Pages 84-85: "Refuge." *Illustration by the author.*

One sip of this will bathe the drooping spirits in delight,
Beyond the bliss of dreams. —*Milton*

The most trying hours in life are between four o'clock and the evening meal. A cup of tea at this time adds a lot of comfort and happiness.

—*Royal S. Copeland, M.D.*

Cha-no-yu emphasizes the enlightening value of the need for economy so that it is more stimulating to be poor than rich, for if the wealthy man merely acts as such he is only a dull study in the obvious. —*A. L. Sadler*

Come, oh come ye tea-thirsty restless ones—
The kettle boils, bubbles
And sings,
Musically.

—Rabindranath Tagore

Drink a lot of tea and it will restore your spirits
to full strength.

—Eisai

Thank God for tea! What would the world do
without tea? How did it exist? I am glad I was not
born before tea.

—Sydney Smith

Tea! Thou soft, thou sober, sage, and venerable liquid, thou innocent pretence for bringing the wicked of both sexes together in a morning; thou female tongue-running, smile-smoothing, heart-opening, wink-tipping cordial, to whose glorious insipidity I owe the happiest moment of my life, let me fall prostrate thus, and adore thee.

—*Colley Cibber*

O tea! O leaves torn from the sacred bough! O stalk, gift born of the great gods! What joyful region bore thee?

—*Pierre Daniel Huet*

The best of Queens, and best of herbs, we owe
To that bold nation, which the way did show
To the fair regions where the sun doth rise,
Whose rich productions we so justly prize.

—*Edmund Waller*

There is a great deal of poetry and fine sentiment
in a chest of tea.

—*Ralph Waldo Emerson*

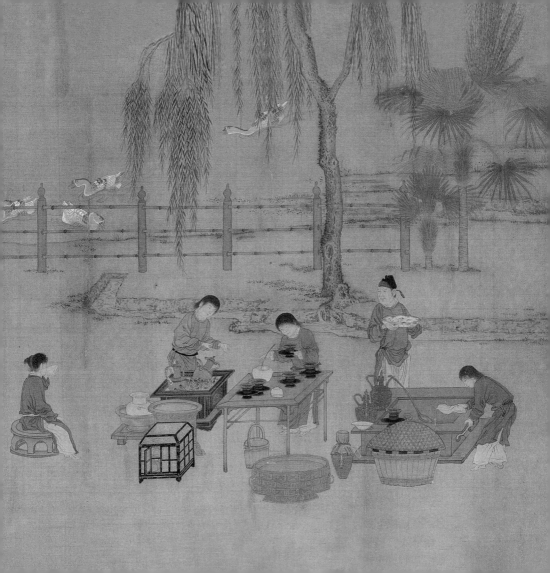

Tea may be the oldest, as it surely the most constantly congenial, reminder of the West's debt to the East...Because we in the West have shared in the drink for so long, it is good that we begin to share as well in the literature about the drink and its meaning.

—*Francis Ross Carpenter*

Ferryman, for tea, scoop up those reflections of cherry blossoms.

—*Hoitsu*

Opposite: Eighteen Scholars of the T'ang. *Traditionally attributed to Emperor Hui-tsung. From the collection of National Palace Museum, Taipei.*

In art the Present is the eternal. The tea masters held that real appreciation of art is only possible to those who make of it a living influence. Thus they sought to regulate their daily life by the high standard of refinement which they obtained in the tearoom.

—*Kakuzo Okakura*

Tea should not be an exhibition of the things one owns. Instead, the purity of one's heart should be displayed.

—*Sen Rikyu*

I received a small brick of tea,
And brewing it, I felt cool;
I can do with the wind what I will.
Why should I need paradise?
My whole body is floating amid the clouds.

—*Gido Shushin*

If I, the boiling water,
And you, the tea;
Then your fragrance
Has to depend solely upon my plainness.

—*Dominic Cheung, Drifting*

Where there's tea there's hope. —*Arthur W. Pinero*

All connoisseurs of tea are particular about tea utensils. They always prefer choice tea leaves and exquisite utensils, which they consider as part and parcel of the ritual of savoring tea.

—*Ling Ping Xiang*

Nowadays industrialism is making true refinement more and more difficult all the world over. Do we not need the tearoom more than ever?

—*Kakuzo Okakura*

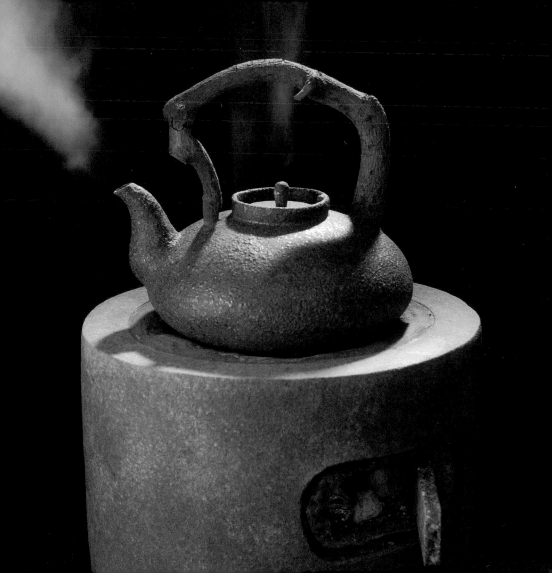

There is the fairest of ladies in my house,
Her face, the purest of white.
So fair is she, we call her Fine Silk
Her every feature—her mouth and teeth—are so
elegant.
She has an older sister, Fragrant Grace,
With the eyes and brow of ancient art
They fly about the woods and fields
Searching for blossoms,
Even through wind and rain
Suddenly, they become impatient and rush home—
Desiring some tea, they race back
To sit by the hearth, madly blowing on the
kettle's flames.

—*Zhou Shi*

Our camp-kettle, filled from the brook, hummed doubtfully for a while, then busily bubbled under the sidelong glare of the flames; cups clinked and rattled, the fragrant steam ascended, and soon this little circlet in the wilderness grew aswarm and genial as my lady's drawing room.

—Alexander Kinglake

Flower arrangements bring some of nature's most glorious creations into our lives and tea experiences. They enlighten a room and bring to it color, vibrancy, fragrance and peace. They also teach the Zen ideal of impermanence as they wither and die. Customarily, the used flowers were buried or thrown gently into the river. The ideals of flower arranging are often also the ideals of tea: to combine Heaven and Earth through the medium of man. The arrangement should be suggestive of the Earth and nature, but also the sublime and quiet of Heaven.

—*A. D. Fisher*

Opposite: An old *gaiwan* called me to tea.

Tea may, of course, be served without any formality. Hot water may be poured over ordinary tea without thought as to the manner in which it is done. But those who practice the art of Cha-no-yu follow a regulated mode of serving with utensils carefully selected and correctly arranged. It is the elaboration of details which gives additional pleasure to the tea-drinker.

—*Yasunoke Fukukita*

Tea is best when enjoyed in pleasant surroundings, whether indoors or out, where the atmosphere is tranquil, the setting harmonious.

—*John Blofeld*

"Do you want your adventure now," Peter said casually to John, "or would you like to have your tea first?" Wendy said, "Tea first, quickly."

—*J.M. Barrie*

Come along inside…We'll see if tea and buns can make the world a better place. —*Kenneth Grahame*

Picture you upon my knee,
Just tea for two, and two for tea. —*Irving Caesar*

We have good and bad tea, as we have good and bad paintings—generally the latter. There is no single recipe for making the perfect tea, as there are no rules for producing a Titian or Session.

—*Kakuzo Okakura*

Iced tea is too pure and natural a creation not to have been invented as soon as tea, ice, and hot weather crossed paths. —*John Egerton*

Tea's proper use is to amuse the idle, and relax the studious, and dilute the full meals of those who cannot use exercise, and will not use abstinence. —*Samuel Johnson*

Tea has the ability to improve our lives as a drink and a Dao, and part of that is through living responsibly, learning about how to live in harmony with the Earth. The universe is as alive as the beings that course through it. Harming the Qi of a land is only hurting ourselves. Arbor based agriculture is the only way to ensure the continuation of tea. And without tea there is no tea culture to speak of. Cha Dao starts on the farm.

—*Zhou Yu*

The perfect temperature for tea is two degrees hotter than just right. —*Terri Guillemets*

The wild duck soars and then circles
Over my orchard.
The fruit has fallen, ripe and ready to pick.
I yearn for flowers that bend with the wind and rain.
In my mind I write a play about tea.
And the wind sighs amongst the pots and cauldrons.

—Tso Ssu

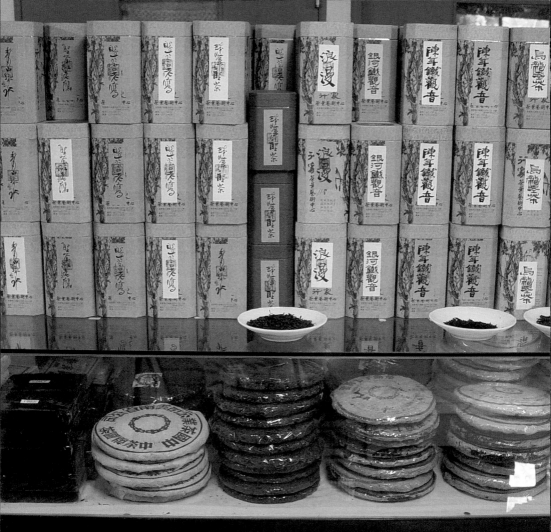

We were overwhelmed by the enormity of the tasks ahead. Mary had given us a bottle of milk and a spoonful of loose tea, and so, unable to decide what to do, we did what all Irish men and women do: we had tea. Suddenly the sun appeared and not for the first or last time we felt it uplifting us and changing everything. It seemed like a holiday. — *Niall Williams and Christine Breen*

Ecstasy is a glass full of tea and a piece of sugar in the mouth. — *Alexander Puskin*

Opposite: Puerh tea of various ages at a tea shop.

From what enchanted Eden came thy leaves
That hide such subtle spirits of perfume?
Did eyes preadamite first see the bloom,
Luscious Nepenthe of the soul that grieves?

—*Francis S. Saltus*

In learning Cha-no-yu, as you study and progress through each of the stages, you should now and again return to the very beginning. —*Sen Rikyu*

The cup of tea on arrival at a country house is a thing which, as a rule, I particularly enjoy. I like the crackling logs, the shaded lights, the scent of buttered toast, the general atmosphere of leisured coziness.　　　　　　　　—*P. G. Wodehouse*

She had that brand of pragmatism that would find her the first brewing tea after Armageddon.
　　　　　　　　　　　　　　　—*Clive Barker*

American-style iced tea is the perfect drink for a hot, sunny day. It's never really caught on in the UK, probably because the last time we had a hot, sunny day was back in 1957.　　　—*Tom Holt*

CHAPTER FOUR

GOOD COMPANY

When I draw *tokutoku* fresh water, please come to
the first tea gathering. *—Sodo*

Come, let us have some tea and continue to talk
about happy things. *—Chaim Potok*

Pages 112-113: "I got it myself from the mountain stream." *Illustration by the author.*

Even from dawn to nightfall as you await a new guest, as dew settles on the woven bamboo fence, brushwood gate, and the vines on the mountain path, never let recede the kettle's sound of the wind in the pines. —*Kobori Enshu*

Tea beckons us to enjoy quality time with friends and loved ones, and especially to rediscover the art of relaxed conversation. —*Dorothea Johnson*

There were two good friends, Chokei and Hofuku. They were talking about the Bodhisattva's way, and Chokei said, "Even if the *arhat* (an enlightened one) were to have evil desires, still the Tathagata (Buddha) does not have two kinds of words. I say that the Tathagata has words, but no dualistic words." Hofuku said, "Even though you say so, your comment is not perfect." Chokei asked, "What is your understanding of the Tathagata's words?" Hofuku said, "We have had enough discussion, so let's have a cup of tea!"

—*Shunryu Suzuki*

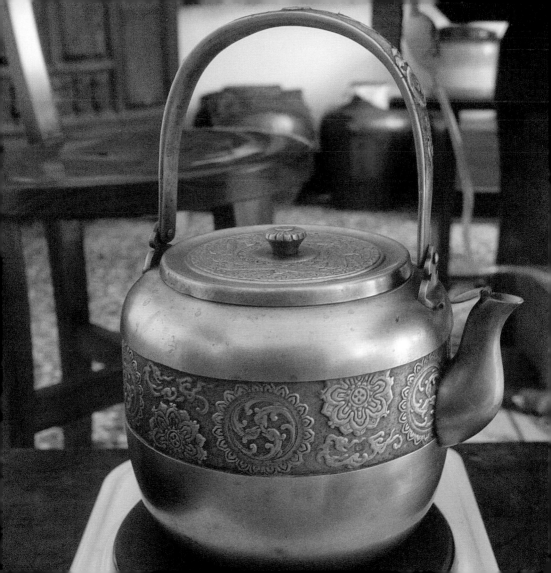

Out of respect to our guests, we serve them tea.

—*Chinese proverb*

Many collectors, when asked to show their favorite Yixing teapot, will reach back into their shelf and pull out some small and cheap first purchase that served them well for many years and was like a friend that supported them as they grew in understanding of tea and teaware both.

—*Zhou Yu*

A large party is distracting, whereas the company of two or three relaxed and friendly people contributes to the enjoyment of unusually fine tea.

—*John Blofeld*

The grandfather plants and tends the tea bushes, the father harvests the tea, and the son drinks it.

—*Chinese Adage*

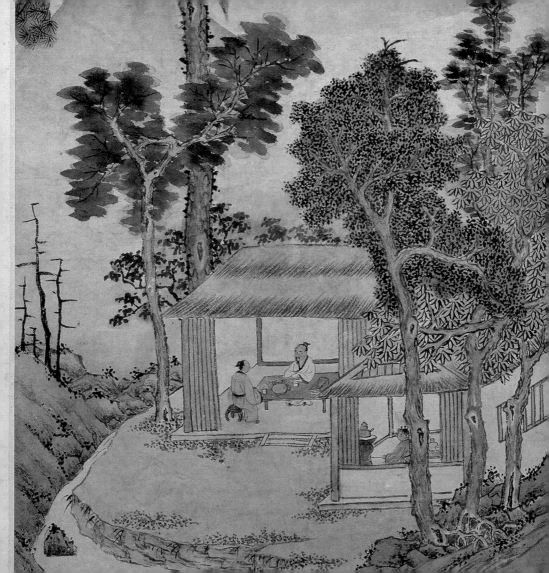

I do not think that, considered from the point of view of human culture and happiness, there have been more significant inventions in the history of mankind, more vitally important and more directly contributing to our enjoyment of leisure, friendship, sociability, and conversation than the inventions of smoking, drinking, and tea.

—*Lin Yu Tang*

In Tea the host is simplicity and the guest elegance. If all is done in sincerity it is better than a thousand graces. —*Matsudaria Naritada*

Opposite: Brewing Tea. *Illustration by Wen Cheng-ming, Ming Dynasty. From the collection of the National Palace Museum, Taipei.*

Take care not to spoil its purity,

For drinking it wipes clean all dust and pain—

A draught of spiritual grace.

From the mountain,

Where it naturally lives,

I brought a tree to my own untamed garden.

The tree, to my great delight, flourished,

And now I can invite my friends over for some.

<div align="right">

—*Wei Ying Wu*

</div>

Respectfully preparing tea and partaking of it mindfully creates heart-to-heart conviviality, a way to go beyond this world and enter a realm apart. No pleasure is simpler, no luxury cheaper, no consciousness-altering agent more benign.

—*James Norwood Pratt*

Tea and books—mmmmmm, two of life's exquisite pleasures that together bring near-bliss.

—*Christine Hanrahan*

With just a simple kettle, you can make tea; it is foolish to possess too many utensils. —*Sen Rikyu*

It is written in the Chinese school manual concerning the origin of habits and customs that the ceremony of offering tea to a guest began with Kwanyin, a well-known disciple of Lao Tzu, who first at the gate of the Han Pass presented to the "Old Philosopher" a cup of the golden elixir.

—*Kakuzo Okakura*

Opposite: "Streaming Dao." *Illustration by the author.*

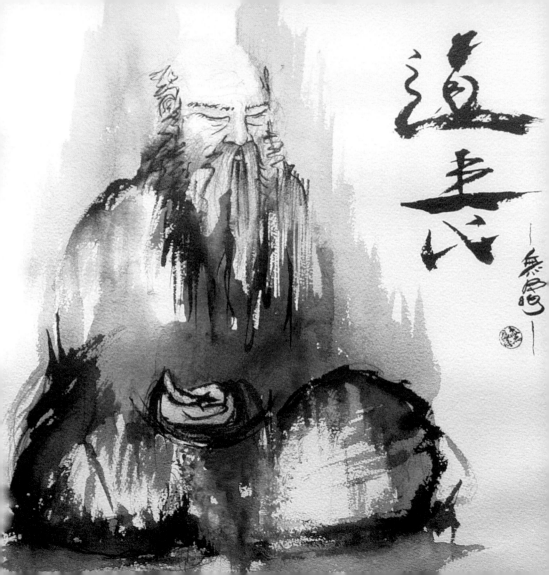

When the mind, having freed itself from the trammels of past and future, is fully concentrated on the Here and Now, a whole range of pleasures involving ears, eyes, nose, palate, and mood can be enjoyed by two or three people who have come together to make and drink fine tea.

—*John Blofeld*

Come and share a pot of tea,
My home is warm and my friendship's free.

—*Emilie Barnes*

One winter night
A friend dropped in.
We drank not wine but tea.
The kettle hissed,
The charcoal glowed,
A lucid moon shone outside.
The moon itself
Was nothing special—
But, oh, the plum blossoms!

—*Tu Xiao Shan*

Tea

Fragrant leaves

Tender buds

Companion of monks and poets

And dearly beloved of hermits

Prepared in cups of milky jade

Couched on cloth of red silk

A rich amber brew

Releases one from tedious formality

At night it accompanies gleaming moonlight

At dawn accords with crimson clouds

It bridges the gulf between us and the ancients

And expels the intoxicating fumes of wine.

—*Yuan Wei Chih*

Opposite: A gathering of old souls in a Taiwanese teahouse.

Originally an outdoor pursuit, tea making in China was an informal affair. All that was needed was a good fire, fresh—preferably mountain—water, a vessel for boiling water, tea leaves, and a bowl to pour the tea into. —*Lam Kam Chuen*

Drinking tea bespeaks a quest that one offers to his friends for the beauty of gestures, of objects and of the heart. —*Sogaku of the Hayami School*

Find yourself a cup of tea. The teapot is just behind you—now tell me about hundreds of things.

—*Saki*

As soon as one approaches the tearoom, the most important aspect of the tea gathering is that the host and guest both compose their mind in a way that is absolutely free of all discursive thinking. This attitude of mindfulness should be kept within and not shown outwardly in pretension.

—*Sen Murata Juko*

Love and scandal are the best sweeteners of tea.

—*Henry Fielding*

Long years have passed; yours in the Way, mine
in worldly life.
I am fortunate to speak with you this autumn.
Drinking fragrant tea until late,
Painful though parting be, I bow to you as I see
you off to distant clouds.

—Emperor Saga, translated by V. Dixon Morris

The afternoon glow is brightening the bamboos,
the fountains are bubbling with delight, the
soughing of the pines is heard in our kettle. Let
us dream of evanescence, and linger in the beau-
tiful foolishness of things. *—Kakuzo Okakura*

Let's have a nice cup of tea and a sit down.

—English Adage

Hundreds of feet of stones
Thick with moss!
Tea brewed with such water
Would attract few guests;
Yet seeing the moon reflected
In its midnight depths
Made me revise
My low opinion.

—Wang Yu Cheng

Moonlight over the hills,
Reflecting on my balcony.
The night is young,
My rustic gate is ajar;
Through the woods,
My friend approaches,
Lantern bobbing.
Smoke curls from the stove;
I call for tea.
The autumn stars have paled,
Barking of wakening dogs,
The sadness of a flute carried on the wind.
And still we sit and talk.
The sky lightens;
Rosy clouds and chilly dew,
The earth moss-covered.

—*Cheng Pan Chiao*

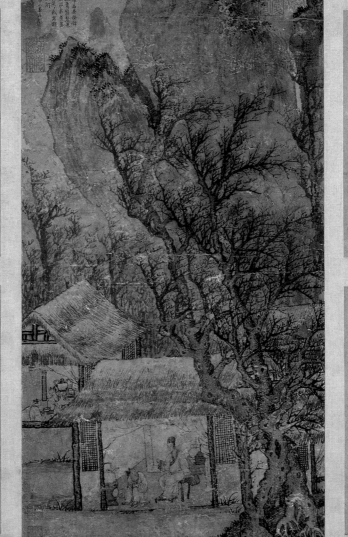

就泉煮茗一快事此事誠宜
寫作圖然間筍巾唐伯虎六
旬絕朦到斯乎
乙未暮春上游沔題

品茶自是幽人事我畫幽人
亦品茶偶一為之寫興耳寵
逯陸羽嗜乎差
乙巳暮春上游沔題

越甌吳鼎淨無塵煮苦觀圖
樂趣真不惡□□端相較量較
未少愧筍巾人
甲午仲春下游沔題

伯虎品茶事邪仙楬來逸韻
依依前巾人若榀安排就進
乎高擊俗已然
壬寅暮春上游沔題

[The tea ceremony] is just another way of celebrating another act of living. The water must be boiled so that it goes through the appropriate stages. The tea must be tasted and tested before it is selected for steeping...When the tea is plucked, where the water is chosen, who is invited to share the tea are of enormous importance.

—*Francis Ross Carpenter*

Drink tea and make friends. —*Chinese proverb*

Opposite: Sipping Tea. *Illustration by T'ang Yin, Ming Dynasty. From the collection of the National Palace Museum, Taipei.*

What part of confidante has that poor teapot played ever since the kindly plant was introduced among us? Why myriads of women have cried over it, to be sure! What sickbeds it has smoked by! What fevered lips have received refreshment from it! Nature meant very kindly by women when she made the tea plant; and with a little thought, what a series of pictures and groups the fancy may conjure up and assemble round the teapot and cup.

—William Makepeace Thakery

May you always have walls for the winds, a roof for the rain, tea beside the fire, laughter to cheer you, those you love near you, and all your heart might desire.

— Irish Blessing

Thus prepared the guest will silently approach the sanctuary, and, if samurai, will leave his sword on the rack beneath the eaves, the tearoom being preeminently the house of peace.

—Kakuzo Okakura

I am so fond of tea that I could write a whole dissertation on its virtues. It comforts and enlivens without the risks attendant on spirituous liquors. Gentle herb! Let the florid grape yield to thee. Thy soft influence is a more safe inspirer of social joy.

—James Boswell

A book reads the better which is our own, and has been so long known to us, that we know the topography of its blots, and dog's ears, and can trace the dirt in it to having read it at tea with buttered muffins.

—Charles Lamb

Beside the pillar in the tearoom on an autumn evening, who is the guest and who is the host?

—Basho

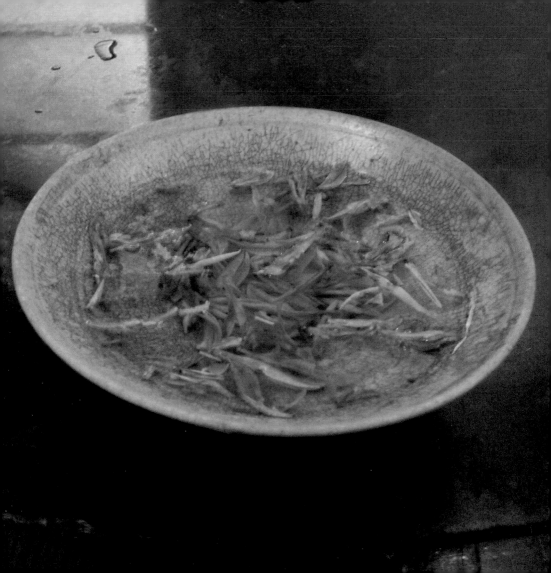

Now stir the fire, and close the shutters fast,
Let fall the curtains, wheel the sofa around,
And while the bubbling and loud-hissing urn
Throws up a steamy column, and the cups
That cheer but not inebriate, wait on each,
So let us welcome peaceful evening in.

—William Cowper

I can drink tea until the cows come home and I
love the atmosphere in tea shops. *—Zola Budd*

The discipline of the tea ceremony also takes a lifetime of study to master. Yet the journey brings rewards, because there is always more to discover and rediscover—not only in the beauty of the craft, but in sharing the simple joy of drinking tea with your friends. —*Shozo Sato*

Another novelty is the tea party, an extraordinary meal in that, being offered to persons that have already dined well, it supposes neither appetite nor thirst, and has no object but distraction, no basis but delicate enjoyment.

—*Jean-Anthelme Brillat-Savarin*

TRADITIONS

The sky is thick, and the dusky twilight hides the
hill-tops;
The dewy leaves and cloudy buds cannot be easily
plucked.
We know not for whom, their thirst to quench,
We're caused to toil and labor, and daily two by
two go.

—A stanza from a traditional tea plucker's song, as
quoted by Williams, *Middle Kingdom*

Pages 144-145: "Beyond the Cha Dao." *Illustration by the author.*

Jady-dew from Uji, scenting and relishing,
Violet floss of Lanka, best of the South;
To read "Tea Classics" is history learned
From beyond the horizon, and
I see my hometown there.

—*Zhao Pu Chu*

In ancient China, people believed that tea should
never be transplanted, and because of this trait,
tea was praised for its tenacity. It exhibits charac-
teristics of both luxury and strength.

—*Ling Wang*

He boils milk with fresh ginger, a quarter of a vanilla bean, and tea that is so dark and fine-leaved that it looks like black dust. He strains it and puts cane sugar in both our cups. There's something euphorically invigorating and yet filling about it. It tastes the way I imagine the Far East must taste.

—*Peter Hoeg*

Opposite: Tasting Tea Made From Spring Water. *Illustration by Chin T'ing-piao, Ch'ing Dynasty. From the collection of the National Palace Museum, Taipei.*

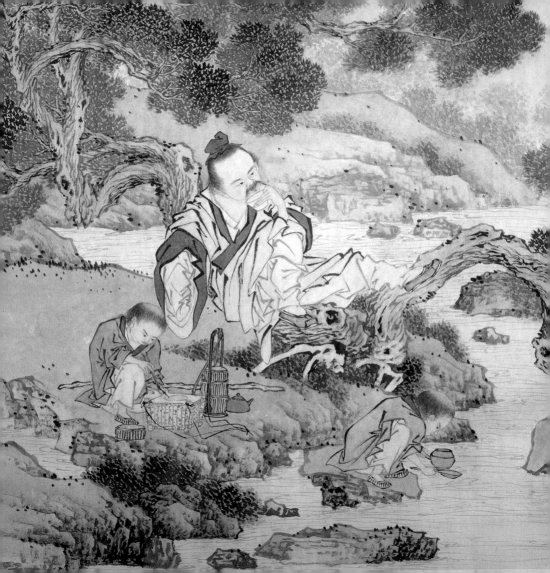

On the peaks of Mount Ling,
A magical thing is gathered: Tea.
Every valley and hill is covered
With this treasure of the Earth.
Graced with the sweet spirit of Heaven.
In the month of the harvest moon,
The farmers will rest but little;
Couples are working at the same task, searching
and picking.

Take water from the currents of the river Min,
Drawn from its pure center.
Select a vessel and choose some ceramics
Produced in Eastern Wu.
Emulate the Duke Liu,
Serving tea with a gourd ladle;
In this way one can perfect
The thick froth, with the "splendor of the brew,"
Lustrous like freshly fallen snow,
And resplendent like the spring's blossom.

—*Tu Yu, Ode to Tea*

The famous Song poet Su Dongpo thought the natural rhythm contained in tea could only be perfected while learning how to collect water and by brewing tea in the wild on a moonlit night, when the bell toll from an ancient temple and the call of the watch from the city wall echoed in the air.

—*Ling Wang*

Tea represents purity. It takes root in the bosoms of hills and valleys, and absorbs rain and dew in high mountains in order to grow green leaves.

—*Ling Wang*

The progress of this famous plant has been something like the progress of truth; suspected at first, though very palatable to those who had the courage to taste it; resisted as it encroached; abused as its popularity seemed to spread; and established in its triumph at last, in cheering the whole land from the palace to the cottage, only by the slow and restless efforts of time and its own virtues.

—*Isaac D'Israeli*

In all circumstances serenity of mind should be maintained, and conversation should be so conducted as never to mar the harmony of the surroundings. The cut and color of the dress, the poise of the body, and the manner of walking could all be made expressions of the artistic personality. These [are] matters not to be lightly ignored, for until one has made himself beautiful he has no right to approach beauty. Thus the tea master [strives] to be something more than the artist—art itself. It [is] the Zen of aestheticism. Perfection is everywhere if we only choose to recognize it.

—*Kakuzo Okakura*

Bright is the setting sun over Kongming Peak,
Harder yet for people of Mt. Wuyingshu to seek.
The site of wind and sacrificial alter rise even today.
And people sit and talk of past and present for aye.
Tea seeds left by Zhuge Liang bring prosperity
for long.
From green mountains, I'm startled by a tea-
picking song.

—Traditional Chinese Poem

Opposite: "Clouds of Stone" by Master Deng Ding Sou.

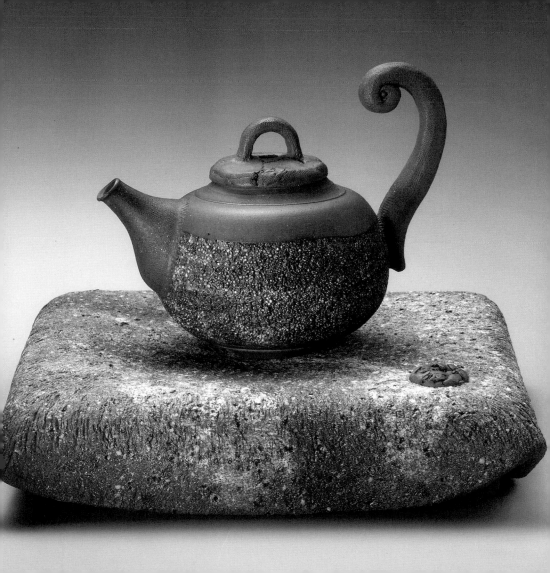

Tea is naught but this:
First you heat the water.
Then you steep the tea.
Then you drink it properly.
That is all you need to know.

—*Sen no Rikyu*

The tea masters guarded their treasures with religious secrecy, and it was often necessary to open a whole series of boxes, one within another, before reaching the shrine itself—the silken wrapping within whose soft folds lay the holy of holies. Rarely was the object exposed to view, and then only to the initiated.

—*Kakuzo Okakura*

[In Chinese herbal medicine] tea possesses a cold nature, and should therefore be used to relieve symptoms like constipation. When tea's essence is at its coldest it is also most suitable to drink. If one is generally temperate, and yet feeling hot or too warm, or if one is given to depression, suffering from migraines or headaches, pain in the eyes, or having trouble with arthritis or soreness of the four limbs, then he may drink tea four or five times to relieve the symptoms. Its liquor is like the sweetest dew of the Heavens. —*Lu Yu*

To fully understand tea one should be well acquainted with four things: the attitude behind the ceremonial and formal aspects of tea drinking, the way in which to prepare the tea, the history of tea, and the Way of Tea. A true "Man of Tea" should be aware of the meaning of ethical conduct and history and should comprehend the truths of Buddhism, Confucianism, and Christianity. In essence the truths of these religions are one. Only a person with such an understanding can be regarded as a "Man of the Way of Tea."

—*Korean tea master, quoted by Stephen Batchelor*

Opposite: "Lu Yu, the Sage of Tea." *Illustration by the author.*

I heard from the monks of Daitoku-ji and Nan-shu-ji that they…open the realm of the Pure Land by proceeding through the *roji*-path, and by making *wabi* tea in a two-mat grass hut, and by undergoing the discipline of gathering firewood and boiling water, they come to realize that the Truth lies in a bowl of tea.

—*Nambo Sokei, as quoted by Plutschow*

Once Sen Rikyu called on one of his senior disciples unannounced while he was gardening. Unflustered by the fact that he didn't have time to prepare, the student cursorily plucked a chrysanthemum flower on the way to the tearoom and gently rest it in the alcove. Student and master enjoyed a tranquil hour of tea without false modesty or any kind of flattery. When they were done, Rikyu said that his student was a student no longer for he understood that the Way of Tea was not a list of dos and don'ts.

—*A. D. Fisher*

It's the ninth day at this temple in the mountains
By the east hedge, golden chrysanthemums blossom
Worldly people drink too much wine
Don't they know the fragrance of tea?

—*Xi Jiao Ren*

Water is the mother of tea; a teapot its father,
and fire the teacher —*Chinese adage*

Teas vary as much in appearance as the different
faces of men. —*Emperor Hui Tsung*

[Seisetsu said:] "My Tea is No-tea, which is not No-tea in opposition to Tea. What then is this No-tea? When a man enters into the exquisite realm of No-tea he will realize that No-tea is no other than the Great Way (*Da Dao*) itself..." Seisetsu's "No-tea" is a mysterious variation of tea. He wants to reach the spirit of the art by way of negation. This is the logic of Prajna philosophy, which has sometimes been adopted by the Zen masters. As long as there is an event designated as "Tea" this will obscure our vision and hinder it from penetrating into "Tea" as it is in itself.

—*Daisetsu Suzuki*

When we enter the way of tea we take our first step thus entangled, trying to distinguish right from wrong, good from bad. Here our first, tentative, puzzled efforts begin. While lost, we seek somehow to discover our genuine mode of cha-no-yu, and thus are led deeper and deeper.

—*Hamamoto Soshun*

If asked
The nature of cha-no-yu,
Say it's the sound
Of windblown pines
In a painting.

—*Sen Sotan*

During the Tang dynasty Buddhist monks placed
a statue of Buddha in the temple tea gardens.
Monks known as tea keepers began the practice of
offering sacrificial cups of tea to Buddha.

—*Mary Lou Heiss*

This morning's tea makes yesterday distant.

—*Tanko, translated by Shaun McCabe and Iwasaki Satoko*

We draw water, gather firewood, boil the water, and make tea. We then offer it up to the Buddha, serve it to others, and drink it ourselves. We arrange flowers and light incense. Throughout all of this, we follow the ways of the Buddha and the great masters of the past. Beyond that, you must seek to achieve your own understanding.

—Rikyu, as attributed in the *Namporoku*

A student of Rikyu asked what kind of room was appropriate for cha-no-yu. He answered, "A room in which much old wood has been used for repairs."

—*Sen Sotan*

What is the name of that mountain—that mountain that lies ahead? After we pass Changdu, we'll get to Ya'an. The butter tea of Batang is sweet. The zanba of Litang so tasty. After passing Baxiu, Mangkang is at hand. What is the name of that river—that river that lies ahead? After we pass Zhongdian, we'll be able to get to Lijiang. Oh my pretty at Dali. My fragrant tea in Puerh. The tea horse road is a long, long one. It leads you all the way to heaven.

—*Traditional Yunnan Song*

Each preparation of the leaves has its individuality, its special affinity with water and heat, its hereditary memories to recall, its own method of telling a story. The truly beautiful must be always in it. —*Kakuzo Okakura*

At the dawn of creation, there must have been tea shrubs growing in the wild, waiting to be discovered. —*Ling Ping Xiang*

Wang Yu Chang eulogized tea as "flooding his soul like a direct appeal, that its delicate bitterness reminded him of the aftertaste of good counsel."

—*Kakuzo Okakura*

The crab eyes are gone and the fish eyes have arisen.
The wind is whispering through the pines.
Strings of pearls fall from a coarse pile
Dizzily, slurries of snow swirl about the edges
Of the boiling water in the silver kettle.
The ancients too often neglected the spirit of
boiling water.

—*Su Xi*

Once a strange monk roamed to Dingshu, Yixing, where he hollered to passers-by: "Riches and honor for sale!" The villagers, however, all sneered at him, and no one paid him any attention. So the monk changed his cry, "Nobody wants to buy honor, but how about riches?" The villagers were now interested and the monk led them to a spot outside the village. There the villagers found marvelous, multicolored clay rich in iron. They used the clay to make pottery which became world-renowned, and a never-ending source of wealth for them.

—Chunfang Pan

Spring scenery is as beautiful as it could be,
Flowers in full bloom in the land of tea.
Beautiful Xishuangbanna is on its soar,
Puerh tea will show its brilliance once more.

—Yang Jiang Ming

The spirit of the tea beverage is one of peace,
comfort and refinement. *—Arthur Gray*

When you hear the splash
Of the water drops that fall
Into the stone bowl,
You will feel that all the dust
Of your mind is washed away.

—*Sen no Rikyu*

The emperors of the past rewarded their most loyal and distinguished ministers with caddies of tea, like the dew of Heaven presented by its son.

—*A. D. Fisher*

The true man of tea hates to be seen as such.

—Sen Joo

Matrons, who toss the cup and see
The grounds of fate in grounds of tea.

—Alexander Pope

The writings of great Zen priests are preferred to all others in the tearoom since they suggest the feeling of drinking tea with reverence in the presence of these sages. *—A. L. Sadler*

CHAPTER SIX

REVIVING
YOURSELF

The outsider may indeed wonder at this seeming much ado about nothing. "What a tempest in a teacup!" he will say. But when we consider how small after all the cup of human enjoyment is, how soon overflowed with tears, how easily drained to the dregs in our quenchless thirst for infinity, we shall not blame ourselves for making so much of the teacup. —*Kakuzo Okakura*

Anyone who sat sipping tea and playing the qin to himself on this verandah would have no need to burn incense if he wanted sweet smells for his inspiration. —*Cao Xue Qin, translated by David Hawkes*

Pages 180-181: "Simplicitea." *Illustration by the author.*

If you are cold, tea will warm you. If you are too heated, it will cool you. If you are depressed, it will cheer you. If you are excited, it will calm you.

—*Gladstone*

Angel came down
From heaven yesterday,
Stayed with me just long enough
for afternoon tea.
And she told me a story yesterday;
About the sweet love
Between the moon and the deep blue sea.

—*Jimi Hendrix*

Her two red lips affected Zephyrs blow,
To cool the Bohea, and inflame the Beau;
While one white finger and a Thumb conspire
To lift the Cup and make the World admire.

—*Edward Young*

You can never get a cup of tea large enough or a
book long enough to suit me. —*C.S. Lewis*

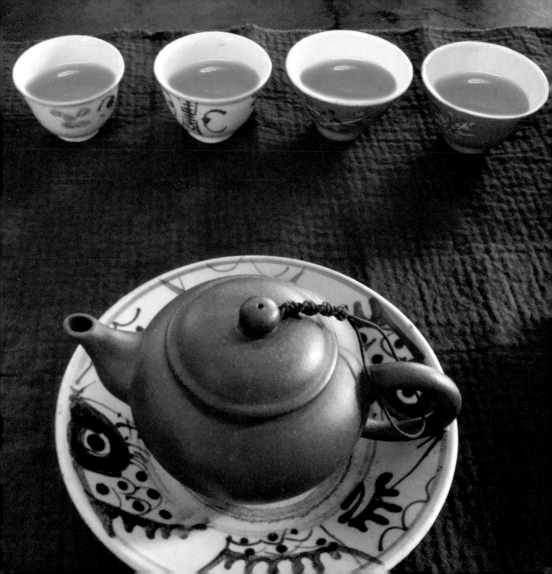

A friend presented me
With tender leaves of Oolong tea,
For which I chose a kettle
Of ivory and gold,
And a bowl of snow-white glaze.
With its clear bright froth and fragrance,
It was like the nectar of the Immortals.
The first bowl washed the cobwebs from my
mind—and the whole world seemed to glow;

A second draught cleansed my spirit,
Like purifying showers of rain;
A third and I was one of the Immortals—
Without any need to practice austerities
To purge our human sorrows.
Worldly people, by going in for wine,
Sadly are deceiving themselves.
For now I know the Way of Tea is real.

—*Chio Jen*

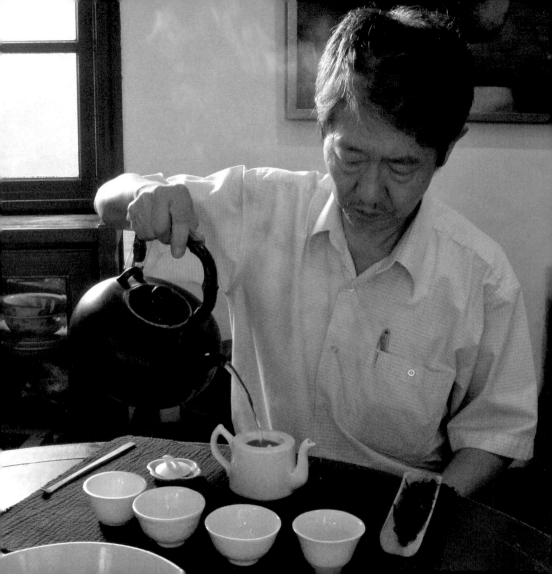

Ever so silently I steal into my chambers.
Deserted.
Empty and barren too is the grand hall.
Waiting.
Patient for a man who will never return.
Resigned, I turn to my tea. —*Wang Wei*

An ideal place for tea drinking is amongst simple furniture and diffused lights with soft music to enhance it. What is most important is that everyone must feel at ease and comfortable, being in the mood to savor the original and natural flavor of the tea. —*Ling Ping Xiang*

Opposite: Master Zhou Yu brews wisdom.

Hot water is the sap that reinvigorates tea with the blush of new life in the teacup or teapot. The leaves become deliciously drinkable thanks to the flavor and aroma that was coddled and tamed into being by skillful tea-processing hands. The Chinese can be counted on to create the most poetic allusions in this regard. For instance, how much more lovely it is to think about this process as they do—the breathing and stretching of the leaves…Think of it as a rebirth from a hibernation of a sort.

—*Mary Lou Heiss*

The sun, Lord of the East, grinds the fragrant
dust of tea.
Bejeweled nectar on the teeth, revives me.
A pure wind envelopes my body.
The whole world seen in a single cup.

—*Kokan, translated by V. Dixon Morris*

The sounds of the tea being made invite the
peach blossoms to peep in through the window.

—*Uson, translated by Shaun McCabe and Iwasaki Satoko*

As daylight breaks let none of us plead tiredness,
But over tea continue our debate.

—Cao Xue Qin, translated by David Hawkes

The Buddha's law also exists in tea.

—Sen, quoted by Ryofu Pussel

I always fear that creation will expire before teatime.

—Sydney Smith

Opposite: Oolong of many colors, many ages.

The monks of the Chan (Zen) sect drank tea not only to refresh themselves; they also connected the realm of tea with that of the Chan sect, and appreciated that the true essence of the world was to seek peace of mind.

—*Ling Wang*

In Zen tea, technical terms are few. Nothing is hoarded or implemented as a treasured secret. If you yearn for a tea based on various topics of study and expend your time absorbing written transmissions, you will fail to attain the genuine Way of Tea.

—*Sen Jakuan Sotaku*

For tea, though ridiculed by those who are naturally coarse in their nervous sensibilities, or have become so from wine drinking, and are not susceptible of influence from so refined a stimulant, will always be the favored beverage of the intellectual.
—Thomas De Quincy

Empty the cup. Throw the cup away completely; destroy it.
—Osho

The black glaze of the teabowl carries with it a flash of lightening.
—Hoitsu

Date-flowers fall in showers on my hooded head
At both ends of the village wheels are spinning thread.
A straw-cloaked man sells cucumbers underneath
a willow tree.
Drowsy when the road is long, I yawn for bed.
Throat parched when sun is high, I long for tea.
I'll knock at this door. What have they for me?

—Su Dongpo

Cha-no-yu is always in danger of becoming like
the gaudy dress of court performers. You should
act with simplicity in all things.

—Sen Rikyu

Opposite: Tea for hundreds, tea for one.

197

Tea's association with colorful, far-off lands fabled for richly textured fabrics, aromatic spices, and delicate porcelain tableware helps to explain how a humble commodity from China came to both fire the imagination and stimulate the palate of upper-class Europeans in the early seventeenth century. Eventually this commodity would capture the attention of the entire Western world. This sweeping history, contained in a single cup of tea, is a riveting narrative that belies the gentle and relaxing nature of this mild-mannered beverage.

—*Mary Lou Heiss*

The love of chaste and refined simplicity, which is the key-note of the Japanese cult of ceremonial tea, has exercised a wholesome influence upon architecture, pottery, landscape gardening, etc. For those who are satiated with looking at elaborate, tawdry, and pretentious works of art, it is a relief to discover subtle beauty and refinement under an inornate and almost barren aspect. When accomplished tea-masters and devotees give entertainments, they know how to attain artistic effect without depending upon what is colorful and gaudy.

—*Yasunoke Fukukita*

The kettle sings well, for pieces of iron are so arranged in the bottom as to produce a peculiar melody in which one may hear the echoes of a cataract muffled by clouds, of a distant sea breaking among the rocks, a rainstorm sweeping through a bamboo forest, or the soughing of pines on some faraway hill. —*Kakuzo Okakura*

My dear, if you could give me a cup of tea to clear my muddle of a head I should better understand your affairs. —*Charles Dickens*

Coffee isn't my cup of tea. —*Samuel Goldwyn*

During the reign of Emperor Yuandi there was an old woman who would fill her kettle with pure mountain water and go to the market to brew deep and pure tea for passersby each day. And, amazingly, no matter how many cups she poured, the kettle never was emptied. The tea was so amazing that there were always those willing to leave a few coins in her cup in return. These she would give to orphans and poor folks at the end

of each day, slipping off again to the mountains each evening. Her transcendent tea was having such an amazing effect on the community that the other tea vendors concocted a scheme and had her arrested for disturbing the peace. She was arrested and taken to jail. That night, the old woman flew out of the window of the jail, her tea things in tow.

—*A. D. Fisher*

Tea is believed to have been introduced into India around 500 AD by Siddhartha, the prince who became the Buddha. It is said that Siddhartha left India, pledging to remain awake for nine years in order to meditate and travel for enlightenment. After five years, he was overcome by sleep. While resting beside a green bush, he picked some of its leaves and chewed them. They revived him, giving him alertness and energy. Siddhartha continued his journey with this new-found tea. When he returned to India he brought a tea seed to be planted.

—Tammy Safi

Tea was such a comfort. —*Edna St. Vincent Millay*

We had a kettle, we let it leak; our not replacing it made it worse, we haven't had any tea for a week...The bottom is out of the Universe!

—*Rudyard Kipling*

The mug from the washstand was used as Becky's teacup, and the tea was so delicious that it was not necessary to pretend that it was anything but tea.

—*Frances Hodgson Burnett*

Dengyo Daishi, a Buddhist monk, is generally credited with bringing tea to Japan after traveling to China around 803–805 AD. He did so after he noticed that tea had the ability to keep the monks in China awake and alert during long hours of meditation and prayer. —*Tammy Safi*

All true tea lovers not only like their tea strong, but like it a little stronger with each year that passes.

—*George Orwell*

CHAPTER SEVEN

REFLECTION
&
MEDITATION

We tend to impose our own self-centered thoughts on the simple drinking of tea. How proficient was the manner of preparation? What kind of teabowl was the tea served in? How was the tea? In this way, drinking is defiled by the "six dusts." When we prepare tea, we must put ourselves wholly into the act. Our minds, however, tend to be drawn to the forms and thus we fall into confusion.

—*Hamamoto Soshun*

Soft yielding Minds to Water glide away,
And sip, with Nymphs, their elemental Tea.

—*Alexander Pope, The Rape of the Lock*

Pages 208-209: "What is left?" *Illustration by the author.*

Tea does our fancy aid,

Repress those vapors which the head invade

And keeps that palace of the soul serene.

—*Edmund Waller*

Realizing that the flavor of tea and the flavor of

Zen are the same,

He scoops up the wind in the pines, his mind

without defilement. —*Dairin Soto*

Ice lumps we thaw and boil to make our tea—
The fuel being damp, they greatly tantalize
The Zen recluse with non-broom sweeps the ground,
His stringless lute-play still more mystifies

—Coa Xue Qin, translated by David Hawkes

In the worship of Bacchus, we have sacrificed too freely; and we have even transfigured the gory image of Mars. Why not consecrate ourselves to the queen of the Camellias, and revel in the warm stream of sympathy that flows from her altar?

—Kakuzo Okakura

The ancients separated those who drink tea into three types: masters, who can discriminate between all qualities of tea and teaware and brew a cup in perfection; collectors, mad for tea and teaware and gathering it up by the tons, and tea devourers who don't discriminate between the finest leaves or dregs and will gulp down a huge bowl of bag tea as quickly as the finest cup.

—*A. D. Fisher*

Tea cannot be learned from a book, only from the heart.

—*Sochi, quoted by Ryofu Pussel*

The essence of the enjoying of tea lies in appreciation of its color, aroma, and flavor, as well as the principles of its preparation: refinement, simplicity, and cleanliness. —*Cai Xiang*

Drink your tea slowly and reverently, as if it is the axis on which the world Earth revolves—slowly, evenly, without rushing toward the future.

—*Thich Nat Hahn*

This brings me to a *koan*-**type** question: If the most important aspect of tea is not tea, then what is the essence of tea? —*John Whitney Hall*

Tea culture is a paradox in itself. Although water and fire seem incompatible from a purely elemental point of view, Lu Yu stressed their interdependence. How could one boil water without fire? And how could a person make tea without water? Therefore, Lu Yu molded the images of fire, birds, fish, and waves on teapots, in order to show the relationship between wind, fire, and water.

—*Ling Wang*

When I makes tea I makes tea as old mother Grogan said and when I makes water I makes water.

—James Joyce

"Take some more tea," the March Hare said to Alice, very earnestly.

"I've had nothing yet," Alice replied in an offended tone, "so I can't take more."

"You mean you can't take less," said the Hatter, "It's very easy to take more than nothing."

—Lewis Carroll

Genuine tea is not a matter of learning secret transmissions; it is not to be put off to some future time of mastery. If Zen tea is not attained in the immediate present, it will never be attained at all.

—*Dennis Hirota*

The gravest failing in the way of tea occurs when consciousness of the long years one has spent in practice turns into complacency. In Zen also, emphasis is placed on practice after attainment. It is said that *satori* is easy, but continuing in right-mindedness is difficult.

—*Hamamoto Soshun*

[A famous Christian teaman] was wont to say, as we several times heard him, that he found suki (the tea ceremony) a great help toward virtue and recollection for those who practice it and really understand its purpose. Thus he used to say that in order to commend himself to God he would retire to that small house (his teahouse) with a statue, and there according to the custom that he had formed he found peace and recollection in order to commend himself to God.

—Joao Rodrigues, a Jesuit Priest, as quoted by Michael Cooper

Opposite: "Pots" by Master Huang Chang Fang.

The tea ceremony is only the beginning. I say onto you: Your every act should be a ceremony. If you can bring your consciousness, your awareness, your intelligence to the act, if you can be spontaneous, then there is no need for any other religion. Life itself will be the religion.　　—*Osho*

Here thou, great Anna! whom three realms obey,
Dost sometimes counsel take—and sometimes tea.
　　　　　　　　　　　　　　　　　—*Alexander Pope*

Long-standing tradition has always prohibited idle chit chat about worldly matters in the tearoom.
　　　　　　　　　—*Rikyu, as attributed in the Namporoku*

When we try to sit for meditation, our minds are often overwhelmed by innumerable thoughts arising from and passing into the depths. For this various breathing exercises were developed to focus the mind in Samadhi before traveling further into silence. The Way of Tea can also achieve this end, for as we pour water and drink we can bring mindfulness to each utensil so that discursive thoughts don't cloud our liquor.

—*A. D. Fisher*

Originally cha-no-yu is without quality or form;
With complete mindfulness, free of distraction,
Simply be in accord with the teachings of Heaven.
There are rules, and yet there are none;
One responding spontaneously and with
adaptability.

—*Master Takuan*

The monks gathered before the image of Bodhi
Dharma and drank tea out of a single bowl with
the profound formality of a holy sacrament.

—*Kakuzo Okakura*

The ancient tea mountains bathed in the setting sunshine.
The old tea trees stretching out their ancient branches
As if turning their nose to the human world and recalling antiquity. *—Yang Jiang Ming*

The daintiness and yet elegance of a china teacup focuses one to be gentle, to think warmly, and to feel close. *—Carol and Malcolm Cohen*

Zhaozhu, Great Master Zhenji, asked a newly arrived monk, "Have you been here before?
The monk said, "Yes, I have been here."
The master said, "Have some tea."
Again, he asked another monk, "Have you been here before?"
The monk said, "No, I haven't been here."
The master said, "Have some tea."
The temple director then asked the master, "Why do you say, 'Have some tea,' to someone who has been here, and 'Have some tea,' to someone who has not?"
The master said, "Director." When the director responded, the master said, "Have some tea."

—*Dogen-Zenji*

An elderly priest in an ancient temple
Tends the incense himself, and himself beats the drum.
The offerings he makes of course are from the surrounding mountains.
The yellow sun sets amidst a tangle of pines;
Autumn stars shine through gaps in the wall.
Why bother to lock the tattered gate?
Now it's pitch black within. Quietly he sits
On an old rush mat. Mind in Samadhi,
Then he brews midnight tea by the stove's light.

—*Traditional Daoist song*

Every tea hour must become a masterpiece to serve as a distillation of all tea hours, as if it were the first and with no other to follow.

—*Francis Ross Carpenter*

Doing nothing is respectable at tea.

—*Sasaki Sanmi*

There are three most deplorable acts in the world: improper education of youth, uninformed appreciation of art, and the waste of fine tea through improper brewing. —*Chinese adage*

All of us who study cha-no-yu, through that
practice, aim towards actualizing respect and
harmony among people. At the same time,
through the same practice, one's self and body
are polished and reflected upon, and one's mind
is brought to a state of clarity. Genuine peace,
peace without discrimination, achieved through
a bowl of tea—this is what I pray will be accom-
plished through the Way of Tea.

—*Sen Soshitsu Hounsai Iemoto*

Having observed the tea-master's way of training his pupils, and having taken part in more than one entertainment, the readers will have noted that cha-no-yu is related to nearly all branches of arts and crafts, as well as to various phases of Japanese home life. It is its many-sidedness that makes cha-no-yu one of the most interesting aesthetic pursuits.

—*Yasunoke Fukukita*

Opposite: "A mendicant lost in dreams of a tea forest." *Illustration by the author.*

Whether formal ritual or more loosely-structured freedom, the tea ceremony itself can become a link to the present moment more easily than other objects which often distract, rather than calm, the mind. Drinking tea quietly fosters a relaxation that will, given enough time, lead to more and more tranquility. As the mind calms down and thoughts of the past and future, imaginations and internal dramas, all still, there is a point where there is only tea—only the movement of the water over the pot, the steeping, the drinking. This connectedness, once experienced, can be life-changing.

—*Ramaputra Chaklavarti*

I know very well that I am in a minority here. But still, how can you call yourself a true tea lover if you destroy the flavor of your tea by putting sugar in it? It would be equally reasonable to put in pepper or salt. Tea is meant to be bitter, just as beer is meant to be bitter. If you sweeten it, you are no longer tasting the tea, you are merely tasting the sugar; you could make a very similar drink by dissolving sugar in plain hot water.

—*George Orwell*

In the Way of Tea, the greatest hindrances are ego and attachment to self. One must never begrudge a master or condescend to a beginner. A tea wayfarer must humbly approach the master, beseeching their guidance, and whenever possible offer such to the inexperienced.

—*Sen Murata Juko*

Tea should be taken in solitude.

—*C.S. Lewis*

The spirit of tea is the spirit of Zen; there is no "spirit of tea" independent of the spirit of Zen. If you do not know the taste of Zen, you do not know the taste of tea • *—Sen Jakuan Sotaku*

Tea, like Zen, allows "no dependence on the written word." It is grasped by mind-to-mind transmission and must be attained through patient practice. *—Hamamoto Soshun*

The Way of Tea:
Follow it, and ever deeper it goes;
Like the fields of Musashi
Where the moon is limpid,
With depths that draw us onwards. —*Rikansai*

My pilgrimage was a trip to the south for ten
thousand li to worship the King of Tea Trees.

—*Zhao Pu Chu*

ABOUT THE AUTHOR

Aaron Fisher was born in Ohio. He studied
anthropology and philosophy, and then went on to
travel the world extensively, spending several years
in India, China, and Japan before settling in Taiwan where
he currently resides. He has been drinking and studying
tea for more than a decade. Aaron is a co-founder and
editor-in-chief of the online magazine *The Leaf*.
He is also a senior editor for *The Art of Tea* and
has written several Chinese and English
articles in other magazines like *Puerh Teapot*
and *Enjoying Tea*. He recently helped translate
and edit Sian Yan Yun's *The Tea Horse Road*.